en famille

For Susan.
w/ love.

Elinor
Carmen

en famille

a poem by robert creeley
photographs by elsa dorfman

granary books 1999

Library of Congress Cataloging -in-Publication Data
Creeley, Robert, 1926-
 En Famille : a poem / by Robert Creeley ; photographs by
Elsa Dorfman.
 p. cm.
 ISBN 1-887123-26-1 (hardcover : alk. paper)
 1. Family Poetry. I. Dorfman, Elsa. II. Title.
PS3505.R43E5 1999
811'.54--dc21 99-34342
 CIP

Designed by Philip Gallo at The Hermetic Press

First Published 1999
Printed on acid-free paper
Printed and Bound in China

Distributed to the trade by D.A.P./Distributed Art Publishers
155 Avenue of the Americas, Second Floor
New York, NY 10013-1507
Orders: (800) 338-BOOK · Tel.: (212) 627-1999
Fax: (212) 627-9484
Granary Books
http://www.granarybooks.com
Elsa Dorfman
http://www.elsa.photo.net

for Harvey, Isaac
Pen, Will
and Hannah

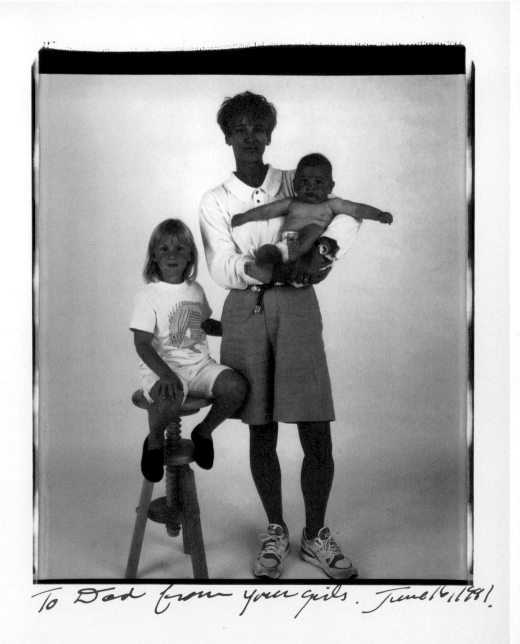

To Dad from your girls. June 16, 1991.

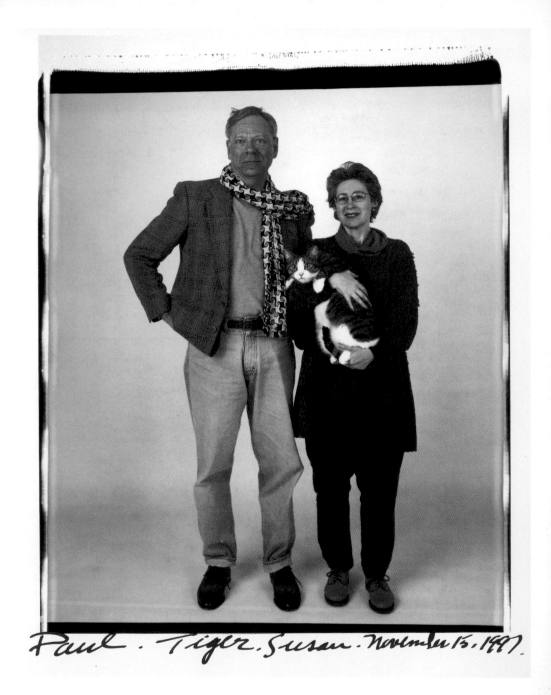

Paul . Tiger . Susan . November 15, 1997 .

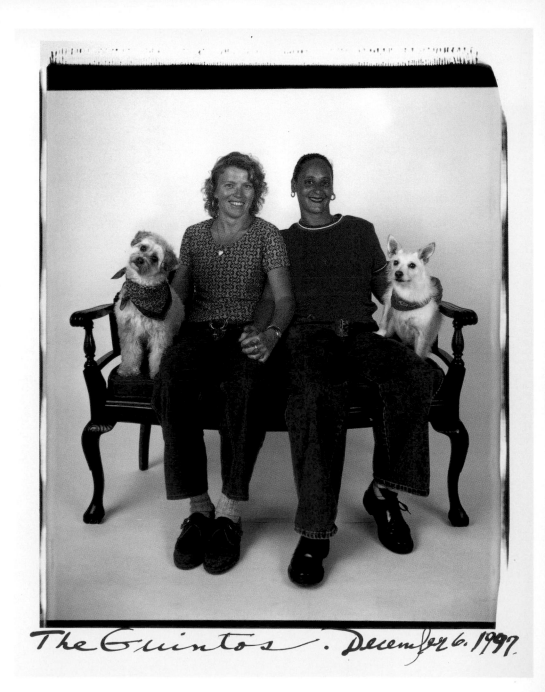

The Guintos . December 6. 1997.

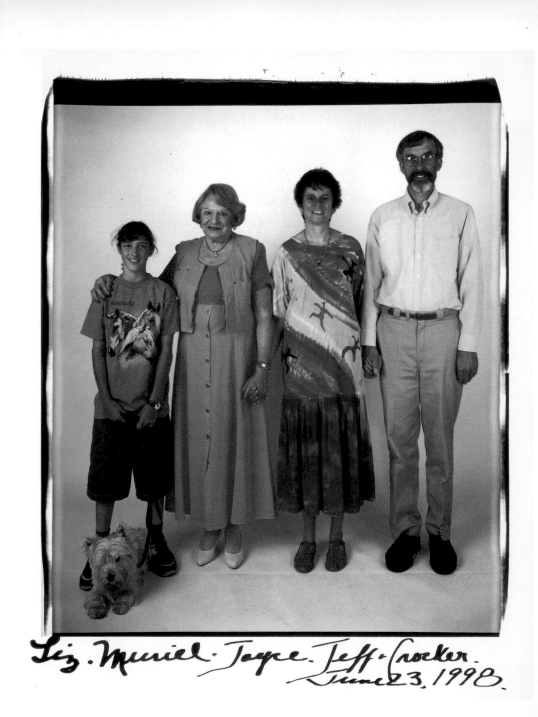

Liz. Muriel. Joyce. Jeff + Crocker.
June 23, 1998.

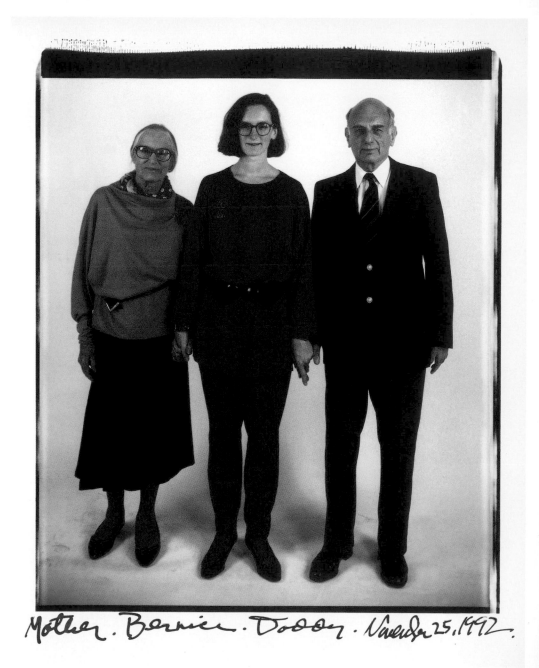

Mother . Bernice . Daddy . November 25, 1992 .

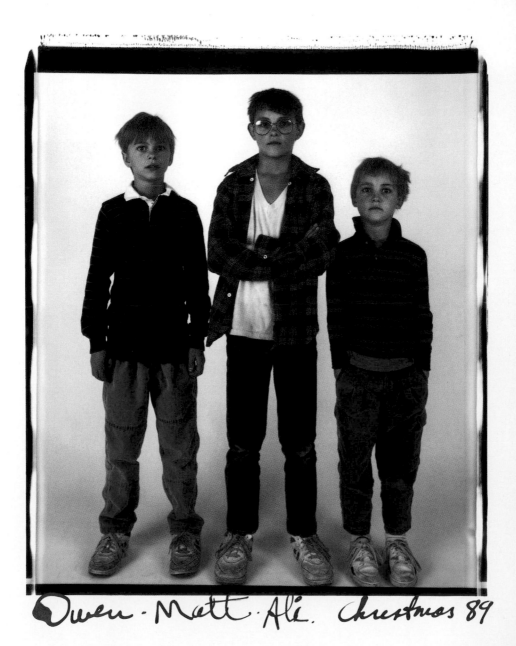

Owen · Matt · Ali · Christmas 89

en famille

I wandered lonely as a cloud…
I'd seemingly lost the crowd
I'd come with, family — father, mother, sister and brothers —
fact of a common blood.

Now there was no one,
just my face in the mirror, coat on a single hook,
a bed I could make getting out of.
Where had they gone?

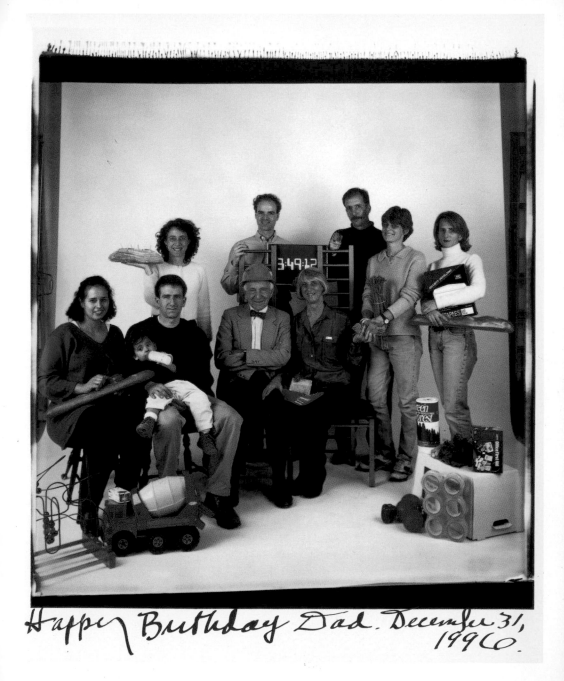

Happy Birthday Dad. December 31, 1996.

What was that vague determination
cut off the nurturing relation
with all the density, this given company —
what made one feel such desperation

to get away, get far from home, be gone from those
would know us even if they only saw our noses or our toes,
accept with joy our helpless mess,
taking for granted it was part of us?

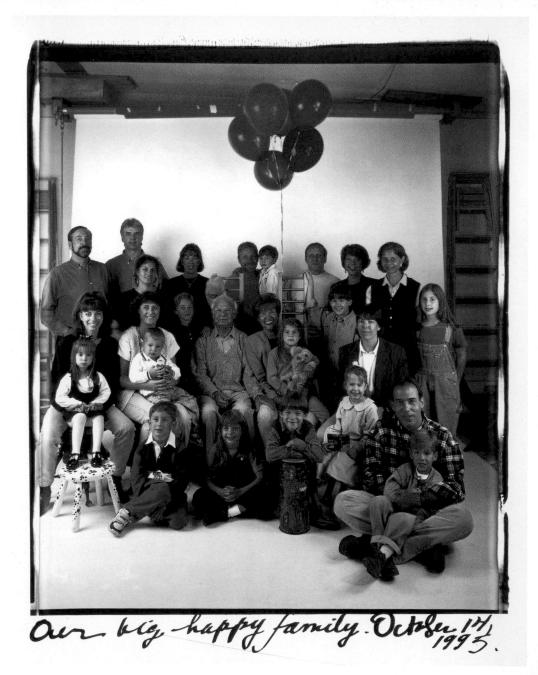

our big happy family. October 14, 1995.

My friends, hands on each other's shoulders,
holding on, keeping the pledge
to be for one, for all, a securing center,
no matter up or down, or right or left —

to keep the faith, keep happy, keep together,
keep at it, so keep on
despite the fact of necessary drift.
Home might be still the happiest place on earth?

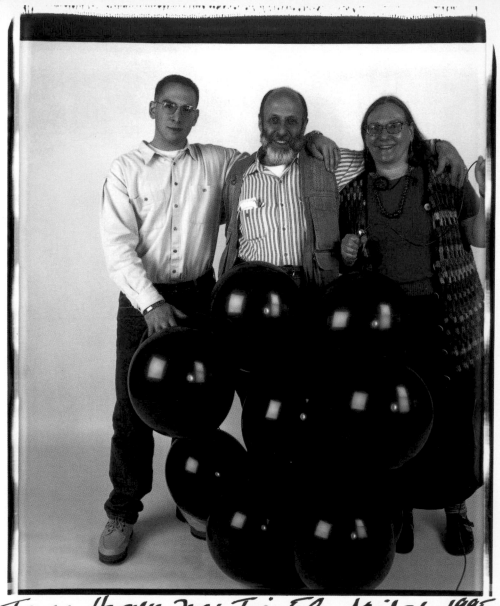

Isaac. Harvey. Me : Iri 58. April 26, 1995.

You won't get far by yourself.
It's dark out there.
There's a long way to go.
The dog knows.

It's him loves us most,
or seems to, in dark nights of the soul.
Keep a tight hold.
Steady, we're not lost.

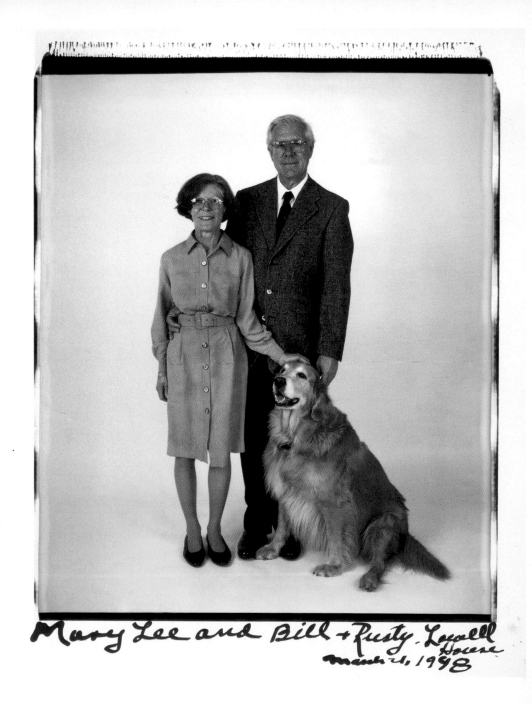

Mary Lee and Bill + Rusty, Lovell House
March 21, 1998

Despite the sad vagaries,
anchored in love, placed in the circle,
young and old, a round—
love's fact of this bond.

One day one will look back
and think of them—
where they were, now gone—
remember it all.

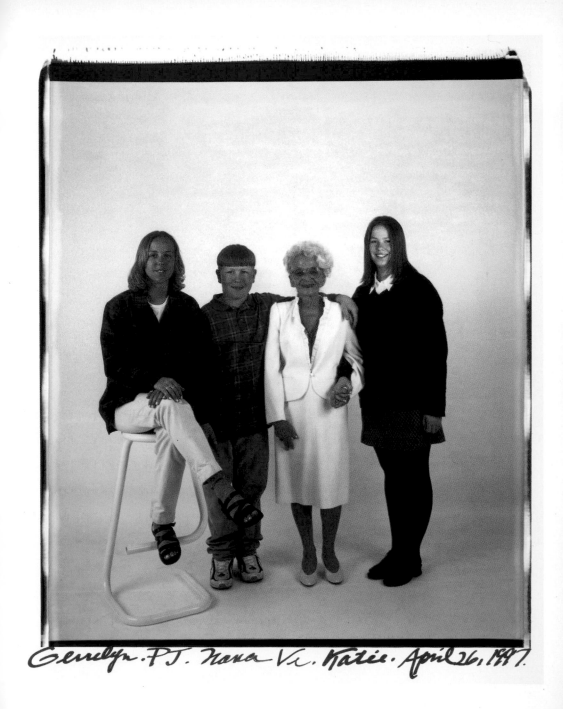

Gerilyn . PJ . Nana Vi . Katie . April 26, 1997.

Turning inside as if in dream,
the twisting face I want to be my own,
the people loved and with me still,
I see their painful faith.

Grow, dears, then fly away!
But when the dark comes, then come home.
Light's in the window, heart stays true.
Call — and I'll come to you.

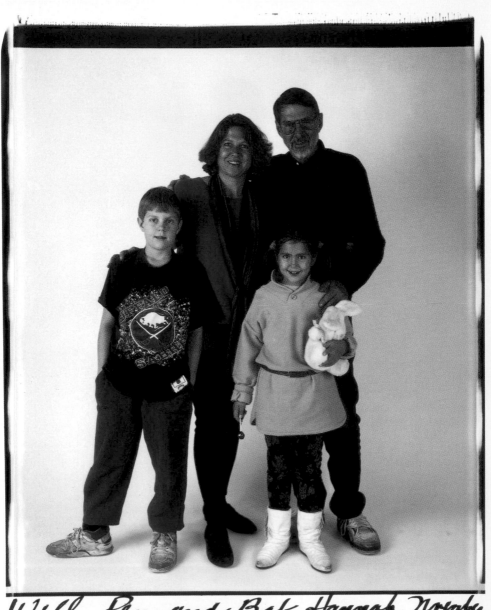

Will - Pen and Bob - Hannah. November
24, 1990.

The wind blows through the shifting trees
outside the window, over the fields below.
Emblems of growth, of older, younger,
of towering size or all the vulnerable hope

as echoes in the image of these three
look out with such reflective pleasure,
so various and close. They stand there,
waiting to hear a music they will know.

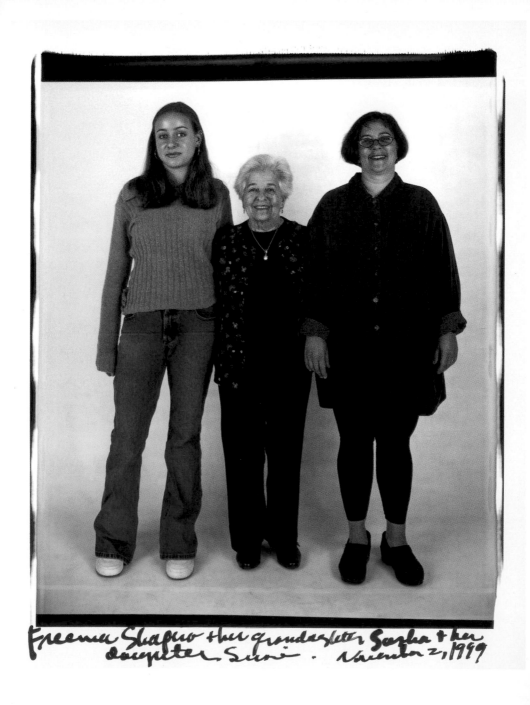

Freema Shapiro, her granddaughter Sasha & her
daughter Susie. November 2, 1999

I like the way you both look out at me.
Somehow it's sometimes hard to be a human.
Arms and legs get often in the way,
making oneself a bulky, awkward burden.

Tell me your happiness is simply true.
Tell me I can still learn to be like you.
Tell me the truth is what we do.
Tell me that care for one another is the clue.

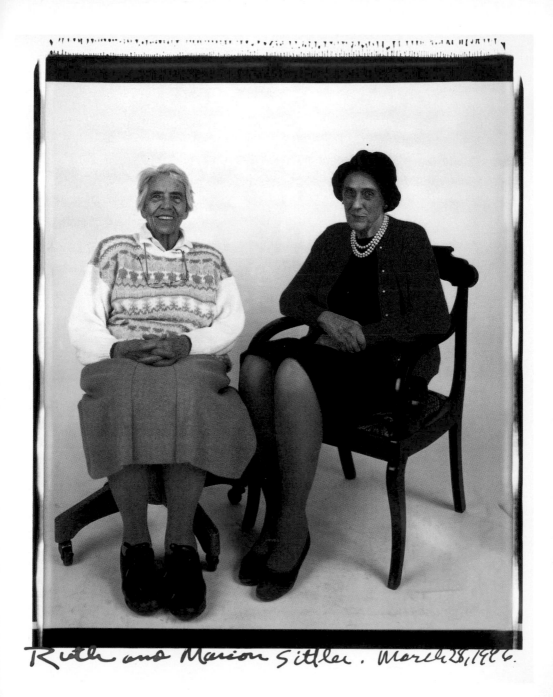

Ruth and Marion Sittler . March 28, 1996.

We're here because there's nowhere else to go,
we've come in faith we learned as with all else.
Someone once told us and so it is we know.
No one is left outside such simple place.

No one's too late, no one can be too soon.
We comfort one another, making room.
We dream of heaven as a climbing stair.
We look at stars and wonder why and where.

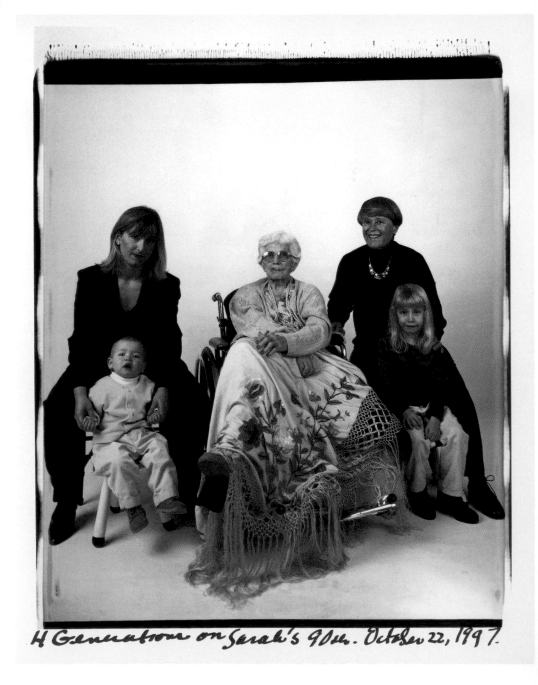

4 Generations on Sarah's 90th. October 22, 1997.

Have we told you all you'd thought to know?

Is it really so quickly now the time to go?

Has anything happened you will not forget?

Is where you are enough for all to share?

Is wisdom just an empty word?

Is age a time one might finally well have missed?

Must humanness be its own reward?

Is happiness this?

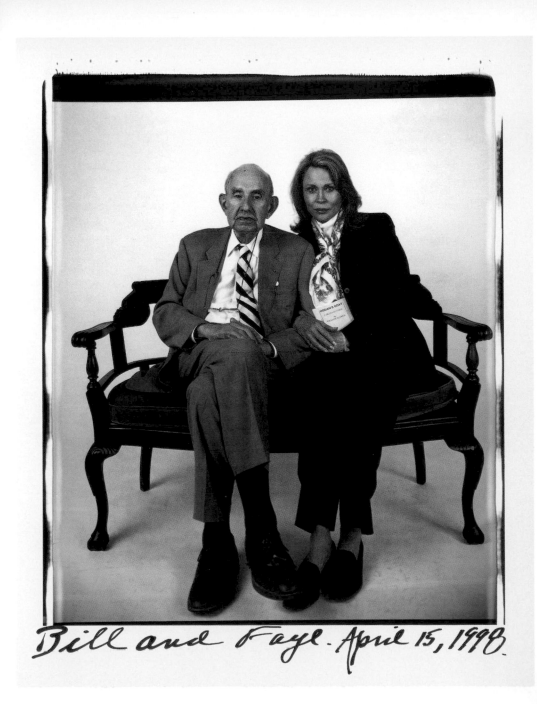

Bill and Faye. April 15, 1998.

en famille

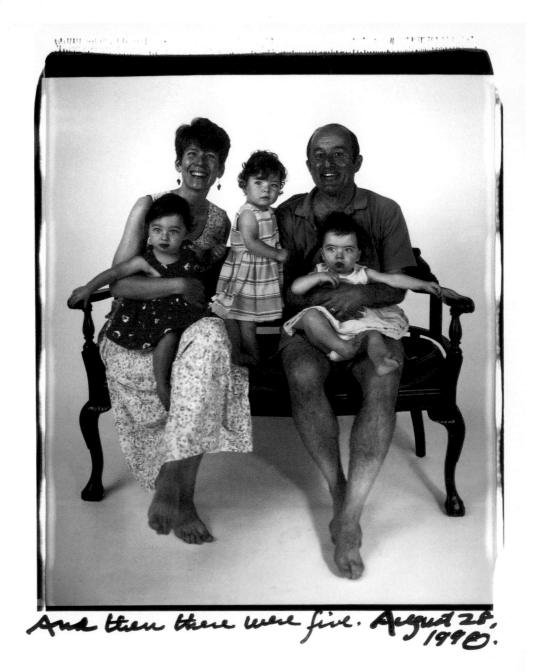

And then there were five. August 28, 1998.

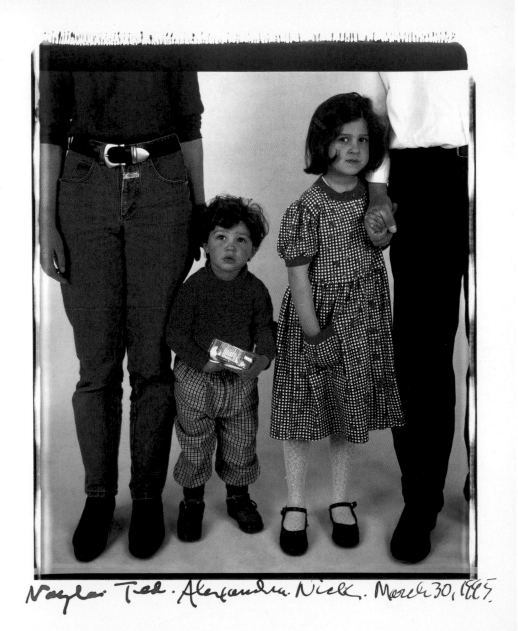

Nayla. Ted. Alexandra. Nick. March 30, 1995.

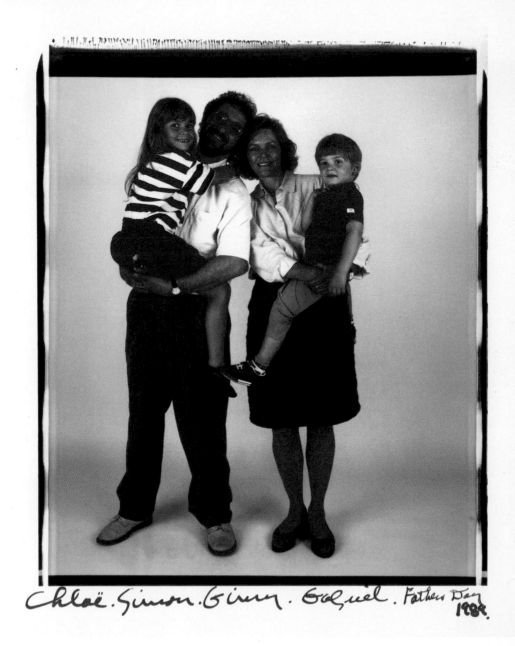

Chloë. Simon. Ginny. Gabriel. Fathers Day 1988.

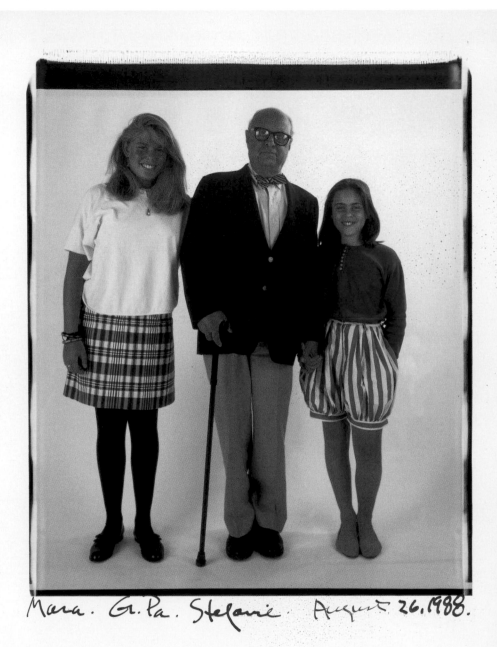

Mara. G.Pa. Stefanie. August. 26.1988.

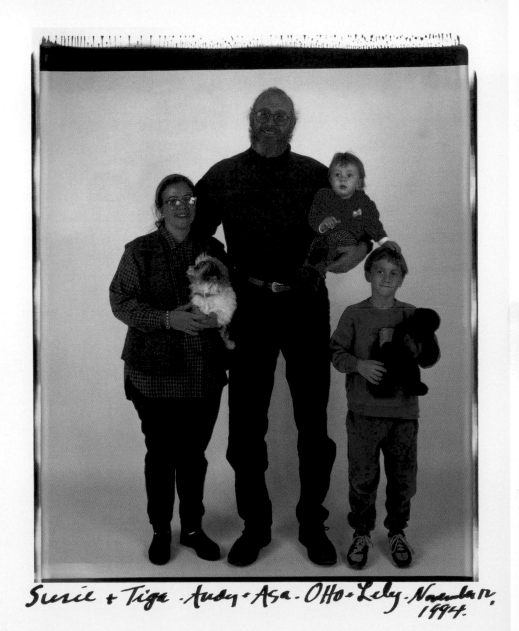

Susie + Tiga · Andy · Asa · Otto · Lely · November 12,
1994.

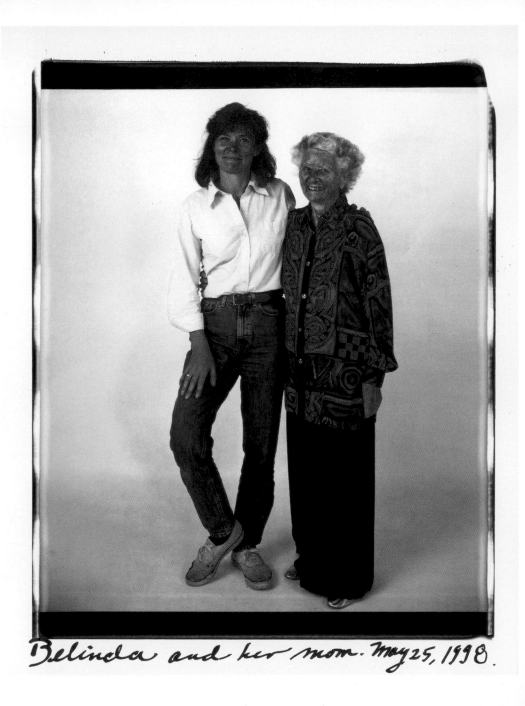

Belinda and her mom. May 25, 1998.

This book is a respect of all who participated and
generously permitted their photographs to be so used:

William Alfred and Faye Dunaway.

Gerrilyn, P.J., Vi, Katie Amirault.

Bill Bossert, Mary Lee Bossert, Rusty.

Steven Gelda, Greg Chaloff, Jamie Chaloff, Jay Comenitz, Corey Comenitz,

Bruce Comenitz, Nancy L. Comenitz, Linda Gelda, Lizzie Gelda,

Debbie Comenitz, Matthew Comenitz, Scott Chaloff, Linda Pressman,

Ros Comenitz, Elliot Comenitz, Nancy G. Comenitz, Julie Carter, Nicole Pressman,

Michael Comenitz, Courtney Chaloff, Brian Comenitz, Jenny Gelda,

Alex Chaloff, Alison Carter, John Pressman, Andrew Pressman.

Emilyann Cramer, Bernice Cramer, Ian Cramer.

Penelope, Robert, Will and Hannah Creeley.

Lauren, Starr and Julie Daniels.

Catherine DiCara, Teresa Spillane, Sophia DiCara, Larry DiCara, Flora DiCara.

Leica, Theresa Guinto, Camilla Marsinelli, Greta.

Tami Kahn, Danny Kahn, Ethan Kahn, Leo Kahn and Emily G. Kahn, Lisa Birk,

Joe Kahn, Nick Haskell, Xandria Birk, Libby Kahn.

Paul Master-Karnik, Tiger, Susan Master-Karnik.

Susan Shapiro Magdanz, Tiga, Andy Magdanz, Asa Paul Magdanz, Otto X Magdanz, Lily.

Nayla, Ted, Alexandra and Nick Mitropoulos.

Owen Shepard Osborn, Matthew Converse Osborn, Alexander Cooke Osborn.

Elizabeth White, Crocker, Muriel Peseroff, Joyce Peseroff, Jeffrey White.

Belinda Rathbone, Rettles Rathbone.

Chloë Schama, Simon Schama, Virgina Papaioannou, Gabriel Schama.

Sasha Shapiro, Freema Shapiro, Susan Shapiro Magdanz.

Isaac Dorfman Silverglate, Harvey A. Silverglate, Elsa Dorfman.

Ruth Sittler, Marion Sittler.

Kit Uchill, Lindsay Tolland, Sarah Malkavy, Audrey Uchill, Jessica Tolland.

Mara Bodis-Wollner, Louis Westheimer, Stefanie Bodis-Wollner.

about the authors

Robert Creeley has been a major force in American poetry since his first book was published in 1952. Presently Samuel P. Capen Professor of Poetry and Humanities at SUNY-Buffalo, his collaborations with artists are the subject of a touring exhibition and catalog entitled *In Company: Robert Creeley's Collaborations* (Castellani Museum / Weatherspoon Art Gallery, 1999). Mr. Creeley lives in Buffalo, NY.

Elsa Dorfman is a portrait photographer and writer from Cambridge, MA. Her portraits of poets, writers, and other friends date to the early sixties and were published in the cult classic *Elsa's Housebook: A Woman's Photojournal* (Godine, 1974). She previously collaborated with Robert Creeley on the book *His Idea* (Coach House Press, 1975). See more of her work at: http://www.elsa.photo.net

The photographs in this book were taken using a Polaroid 20" x 24" camera, one of only six in the world. (Drawing by Elsa Dorfman.)